MW00587505

OCCUPIED

BRIAN
FOUHY

NEW HEROES & PIONEERS

"I just love the urinals" – an unprovoked endorsement from my Mom while talking on the phone about the different photo series I have created.

When you get that kind of unexpected encouragement for a project how do you not pursue it? So I proposed the idea, the publisher thought it was absolutely disgusting, but the more people he talked to he discovered people found the topic interesting (undoubtedly to his surprise), and he began to come around, and he was eventually convinced to pursue the project. And so the adventure began.

I have found myself in a lot of unusual scenarios throughout my career as a photographer, but it was still with trepidation that I walked into that first location I chose to document, my camera and tripod in tow. How do you broach the question of asking to take photos of the bathroom without getting laughed out of the room or knocked out... But to my surprise, while I certainly got my fair

share of odd looks, the request was more often than not greeted with intrigue and enthusiasm. Undoubtedly I would get an encouraging "yes" and sometimes a more apathetic "I don't care what you do, knock yourself out". My request also often lead to conversations I never saw coming, about all the great bathrooms people have used, seemingly it is something we all take a mental note of but never choose to talk about, a heavily taboo topic, that unspeakable, sometimes smelly room that we all have an incredibly necessary use for.

These wonderful conversations led to photographing over 100 bathrooms across the United States, 70 of which made their way onto these pages. Some beautiful, some disgusting, but all have become a piece of me, documenting a moment in time of the experiences I had at each location and the people I met along the way.

BRIAN FOUHY

KGB BAR

40°43'35.5"N / 73°59'23.4"W

STREET ADDRESS
85 east 4th street

CITY
new york, ny

DAY OF THE WEEK
thursday

LIQUID CONSUMED
brooklyn lager – 5 12oz bottles

TIME OF DAY
10:02pm est/03:02 gmt

TIME SPENT AT URINAL
34 mississippi

HANDWASHING SUPPLIES
liquid soap and a high speed
xlerator hand dryer

COMPANY KEPT
a mixed up night of weird with a
good old friend

WEATHER
clear, cold 37°f/2°c night

DISTANCE
4,665mi/7,508km from moscow,
russia (a 9h 25m flight)

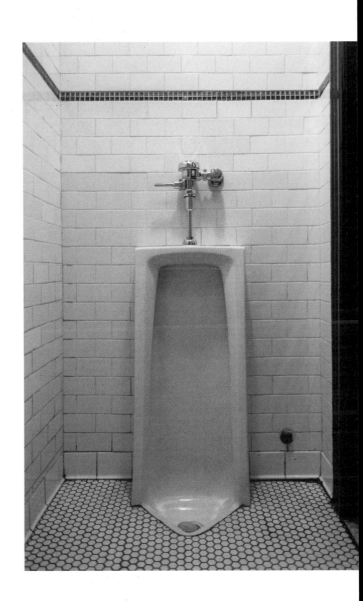

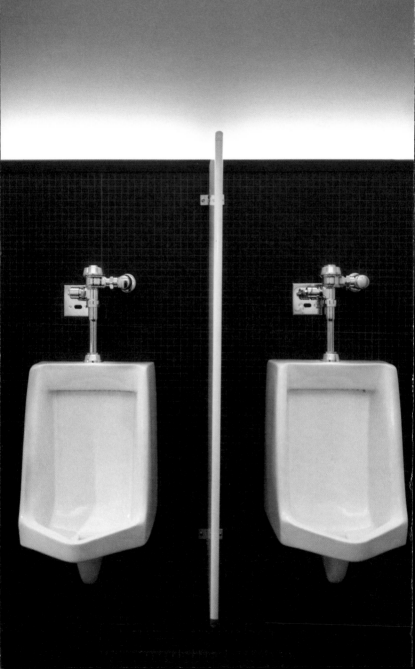

STREET ADDRESS
25 harbor shore drive

CITY
boston, ma

DAY OF THE WEEK
thursday

LIQUID CONSUMED
poland springs – 1 12oz bottle

TIME OF DAY
3:24pm est/20:24 gmt

TIME SPENT AT URINAL
17 mississippi

HANDWASHING SUPPLIES
liquid soap and paper towels

COMPANY KEPT
relishing the nostalgic feelings
evoked from mark dion's
exhibit 'misadventures of a
21st-century naturalist'

WEATHER
freezing 12°f/-11°c
boston afternoon

DISTANCE
58.1mi/93.5km from new
bedford, ma (a 1h 6m drive)

MCSORLEY'S OLD ALE HOUSE

40°43'43.6"N / 73°59'22.9"W

STREET ADDRESS
15 east 7th street

CITY
new york, ny

DAY OF THE WEEK
sunday

LIQUID CONSUMED
light lager – 2 glasses

TIME OF DAY
1:27pm edt/17:27 gmt

TIME SPENT AT URINAL
23 mississippi

HANDWASHING SUPPLIES
liquid soap and paper towels

COMPANY KEPT
lunch time break with a lamb
sandwich and a cold beer

WEATHER
clear, cold 48°f/8°c afternoon

DISTANCE
3,063mi/4,930km from tyrone,
ireland (a 6h 18m flight)

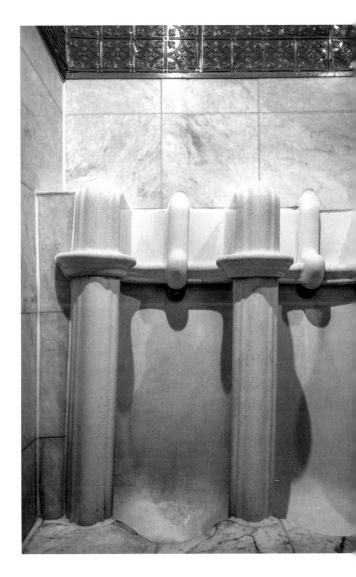

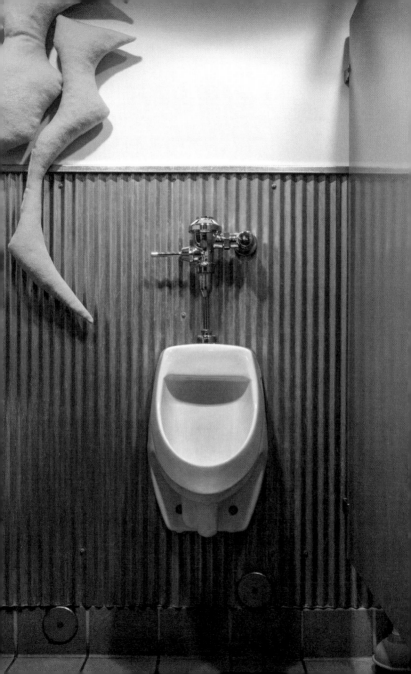

REDLINE

39°45'17.4"N / 104°59'10.3"W

STREET ADDRESS
2350 arapahoe street

CITY
denver, co

DAY OF THE WEEK
sunday

LIQUID CONSUMED
a drink from the water fountain

TIME OF DAY
1:26pm mdt/19:26 gmt

TIME SPENT AT URINAL
17 mississippi

HANDWASHING SUPPLIES
liquid soap and paper towels

COMPANY KEPT
time with myself perusing the
work of the 10th anniversary
resident artist exhibition

WEATHER
cool, slightly chilly
42°f/5°c afternoon

DISTANCE
1,436mi/2,311km from
the redwood forest
(a 23d 7h bike ride)

LARIMER LOUNGE

39°45'35.8"N / 104°59'01.7"W

STREET ADDRESS
2721 larimer street

CITY
denver, co

DAY OF THE WEEK
friday

LIQUID CONSUMED
pbr – 2 16oz cans (tall boys)

TIME OF DAY
10:33pm mdt/04:33 gmt

TIME SPENT AT URINAL
21 mississippi

HANDWASHING SUPPLIES
liquid soap and paper towels

COMPANY KEPT
caroline rose and her band
putting on a hell of a show

WEATHER
a clear, hot 80°f/26°c night

DISTANCE
1,334mi/2,147km from the
rock & roll hall of fame
(a 19h 41m drive)

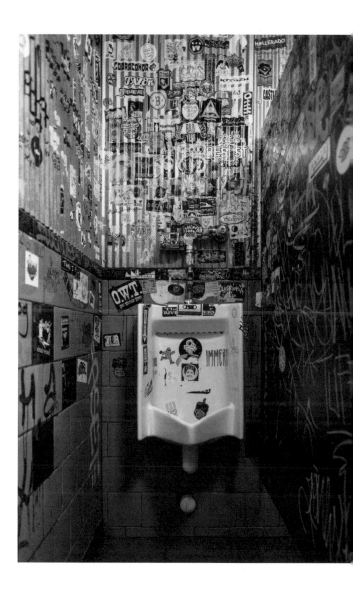

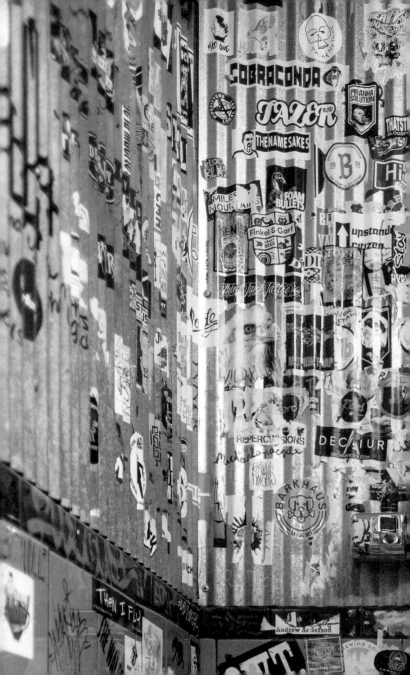

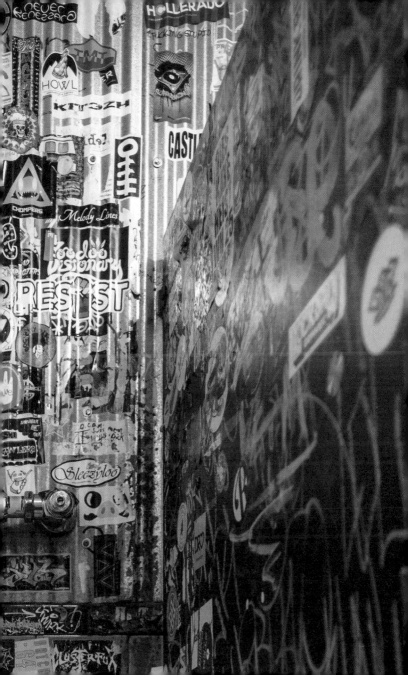

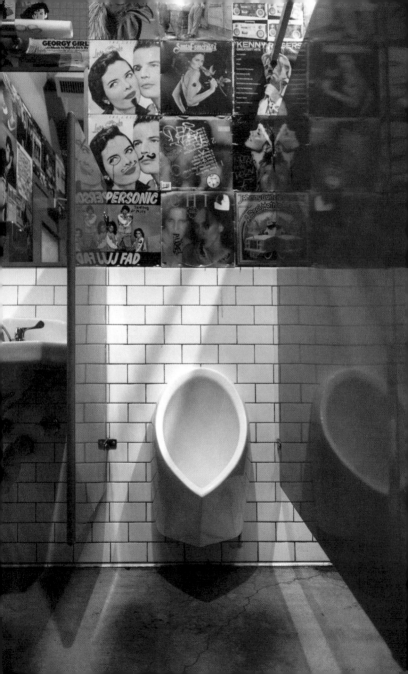

PON PON

39°45'30.7"N / 104°59'11.5"W

STREET ADDRESS
2528 walnut street

CITY
denver, co

DAY OF THE WEEK
friday

LIQUID CONSUMED
czechvar lager – 2 pints

TIME OF DAY
8:07pm mdt/02:07 gmt

TIME SPENT AT URINAL
27 mississippi

HANDWASHING SUPPLIES
liquid soap and paper towels

COMPANY KEPT
fun night with friends celebrating
the opening of william singer
and derek blancey's show 'raw'

WEATHER
hot 91°f/32°c second
night of summer

DISTANCE
7,899mi/12,713km from
dunedin, new zealand
(a 15h 27m flight)

ROCKY MOUNTAIN COLLEGE OF ART & DESIGN

39°44'35.6"N / 105°04'04.2"W

STREET ADDRESS
1600 pierce street

CITY
lakewood, co

DAY OF THE WEEK
thursday

LIQUID CONSUMED
a few sips from the
water fountain

TIME OF DAY
3:31pm mdt/21:31 gmt

TIME SPENT AT URINAL
28 mississippi

HANDWASHING SUPPLIES
deb foam soap and
paper towels

COMPANY KEPT
stopped in to see shelby miles's
show 'a sign of maturity'

WEATHER
hot, humid 93°f/33°c evening

DISTANCE
0.4mi/0.6km from casa bonita
(an 8m walk)

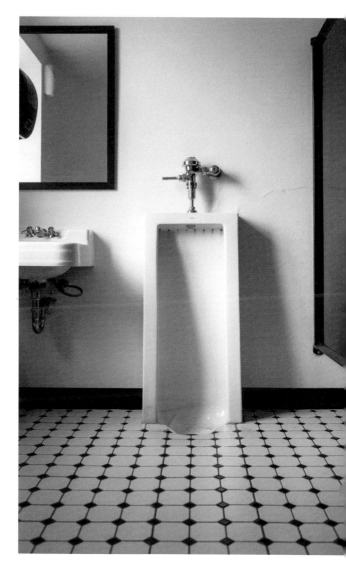

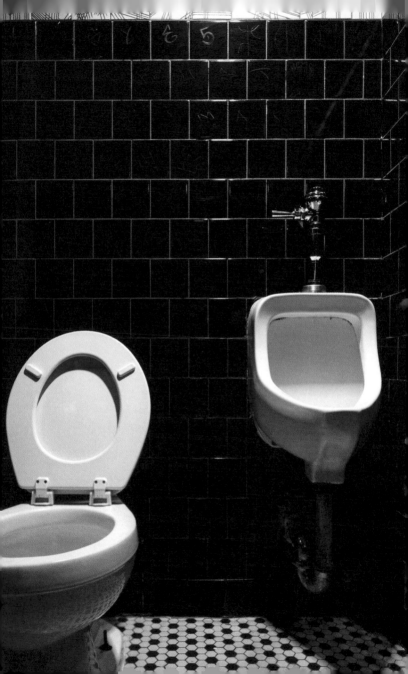

STREET ADDRESS
115 1st avenue

CITY
new york, ny

DAY OF THE WEEK
sunday

LIQUID CONSUMED
brooklyn lager – 2 pints

TIME OF DAY
9:42pm edt/01:42 gmt

TIME SPENT AT URINAL
18 mississippi

HANDWASHING SUPPLIES
liquid soap and paper towels

COMPANY KEPT
saddling up to the bar for a
couple of sunday night beers
after a long tiring weekend

WEATHER
overcast 74°f/23°c spring night

DISTANCE
4,172mi/6,714km from tuscany,
italy (an 8h 23m flight)

LOST LAKE LOUNGE

39°44'23.9"N / 104°56'41.0"W

STREET ADDRESS
3602 east colfax avenue

CITY
denver, co

DAY OF THE WEEK
friday

LIQUID CONSUMED
pbr - 2 16oz cans (tall boys)

TIME OF DAY
11:28pm mdt/05:28 gmt

TIME SPENT AT URINAL
28 mississippi

HANDWASHING SUPPLIES
liquid soap and paper towels

COMPANY KEPT
aaron lee tasjan shredding
his guitar like only aaron
lee tasjan can

WEATHER
a clear, hot 80°f/26°c night

DISTANCE
1,154mi/1,857km from
nashville, tn (a 16h 54m drive)

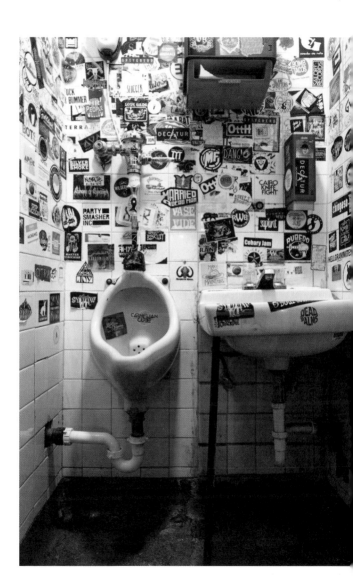

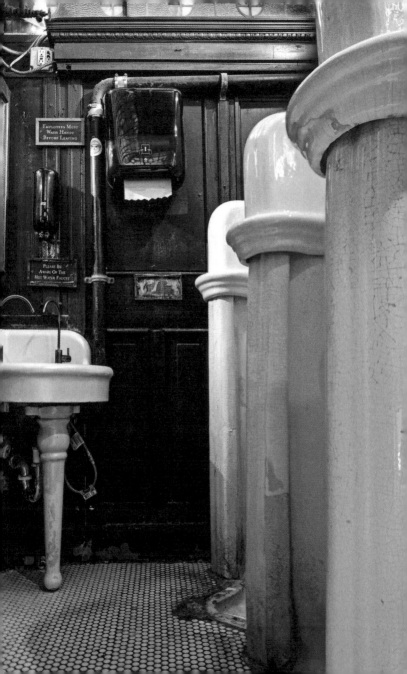

P.J. CLARKE'S

40°45'32.3"N / 73°58'05.5"W

STREET ADDRESS
915 3rd avenue

CITY
new york, ny

DAY OF THE WEEK
sunday

LIQUID CONSUMED
stella artois – 2 pints

TIME OF DAY
4:58pm edt/20:58 gmt

TIME SPENT AT URINAL
26 mississippi

HANDWASHING SUPPLIES
foam soap and paper towels

COMPANY KEPT
friendly bartender and a
cheeseburger – medium rare,
american cheese, fries – a
much needed refuel

WEATHER
overcast, warm 81°f/27°c
late afternoon

DISTANCE
256mi/412km from the kennedy
compound (a 4h 31m drive)

NATIONAL WESTERN COMPLEX

39°46'52.8"N / 104°58'15.7"W

STREET ADDRESS
4655 humboldt street

CITY
denver, co

DAY OF THE WEEK
sunday

LIQUID CONSUMED
coors banquet – 1 16oz can
(tall boy)

TIME OF DAY
4:14pm mdt/22:14 gmt

TIME SPENT AT URINAL
28 mississippi

HANDWASHING SUPPLIES
liquid soap and paper towels

COMPANY KEPT
denver county fair for the
100+ art show, taking home
a couple ribbons

WEATHER
rainy 66°f/18°c afternoon

DISTANCE
847mi/1,363km from the st. louis
arch (16d 18h by horseback)

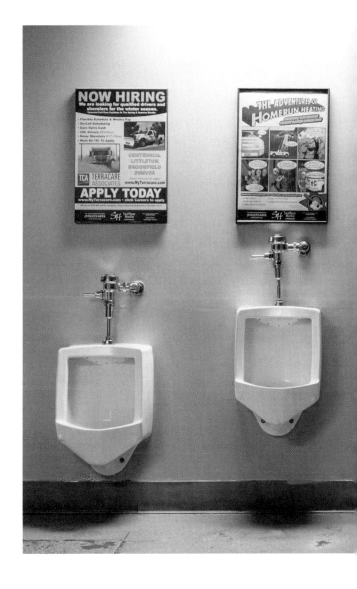

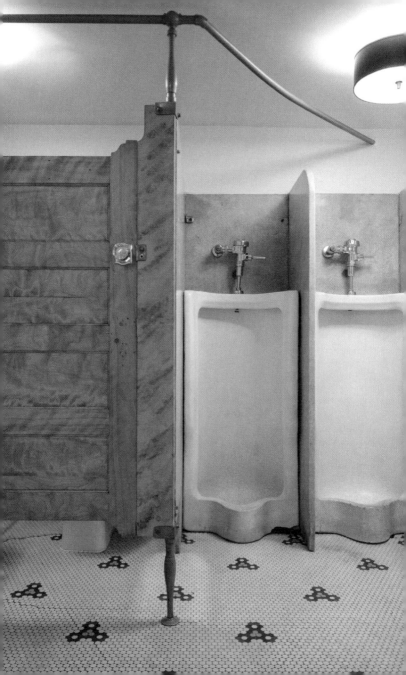

THE OXFORD HOTEL

39°45'08.3"N / 104°59'57.7"W

STREET ADDRESS
1600 17th street

CITY
denver, co

DAY OF THE WEEK
thursday

LIQUID CONSUMED
cold brew - 16oz

TIME OF DAY
10:11am mdt/16:11 gmt

TIME SPENT AT URINAL
20 mississippi

HANDWASHING SUPPLIES
liquid soap and paper towels

COMPANY KEPT
quiet morning in the lobby
before heading to the airport

WEATHER
hazy 78°f/25°c morning

DISTANCE
1,807mi/2,908km from cape
cod, ma (a 3h 55m flight)

IRONTON DISTILLERY & CRAFTHOUSE

39°46'22.6"N / 104°58'42.8"W

STREET ADDRESS
3636 chestnut place

CITY
denver, co

DAY OF THE WEEK
friday

LIQUID CONSUMED
bierstadt slo pour pils – 4 pints

TIME OF DAY
7:58pm mst/02:58 gmt

TIME SPENT AT URINAL
24 mississippi

HANDWASHING SUPPLIES
liquid soap and paper towels

COMPANY KEPT
a fun night gathered with friends
for the final night of side stories

WEATHER
drizzly, cool 45°f/7°c night

DISTANCE
5,221mi/8,402km from munich,
germany (a 10h 23m flight)

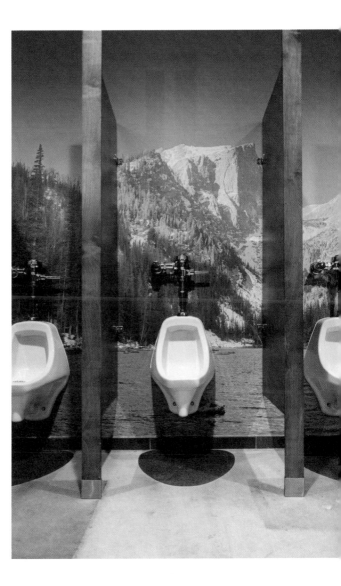

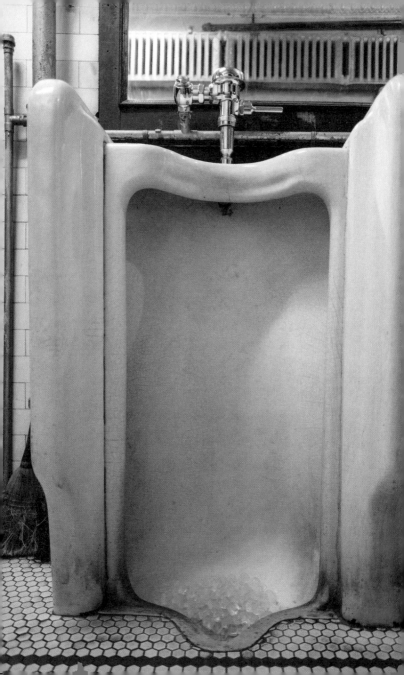

OLD TOWN BAR

40°44'15.2"N / 73°59'21.1"W

STREET ADDRESS
45 east 18th street

CITY
new york, ny

DAY OF THE WEEK
wednesday

LIQUID CONSUMED
guinness – 1 pint

TIME OF DAY
1:32pm est/18:32 gmt

TIME SPENT AT URINAL
27 mississippi

HANDWASHING SUPPLIES
liquid soap and paper towels

COMPANY KEPT
enjoying a quiet afternoon pint
before departing the city for
thanksgiving in massachusetts

WEATHER
cloudy, cool 44°f/6°c
fall afternoon

DISTANCE
372m/598km from plymouth
rock (a 1d 14h boat ride)

CARNEGIE MUSIC HALL

40°26'36.0"N / 79°57'04.0"W

STREET ADDRESS
4400 forbes avenue

CITY
pittsburgh, pa

DAY OF THE WEEK
friday

LIQUID CONSUMED
a long drink from
the water fountain

TIME OF DAY
11:52am edt/15:52 gmt

TIME SPENT AT URINAL
18 mississippi

HANDWASHING SUPPLIES
liquid soap and paper towels

COMPANY KEPT
exploring and getting a
tour of this beautiful
space from jonathan

WEATHER
sweaty, humid 75°f/23°c day

DISTANCE
373mi/600km from carnegie
hall, ny (a 5h 47m drive)

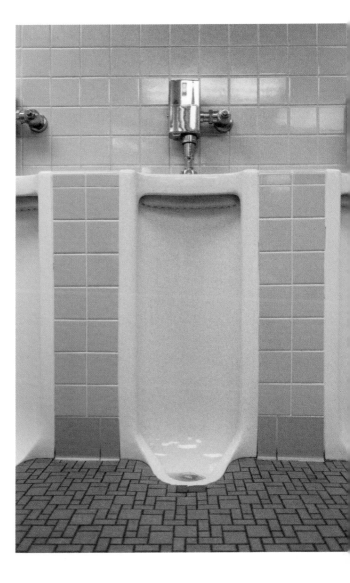

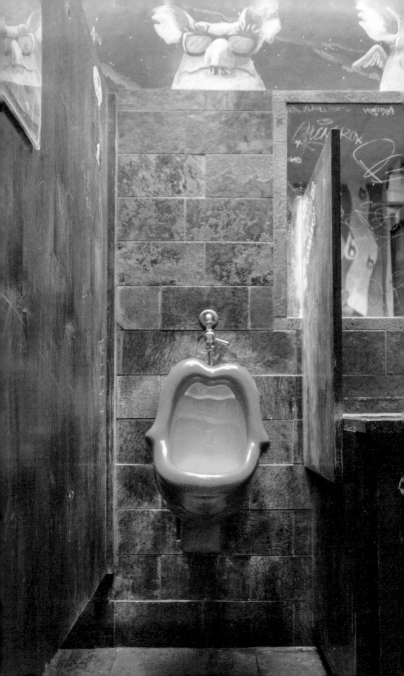

HARRIS GRILL

40°27'21.4"N / 79°55'52.6"W

STREET ADDRESS
5747 ellsworth avenue

CITY
pittsburgh, pa

DAY OF THE WEEK
friday

LIQUID CONSUMED
east end brewing chance
a'shahrs pale ale – 1 pint

TIME OF DAY
2:52pm edt/18:52 gmt

TIME SPENT AT URINAL
31 mississippi

HANDWASHING SUPPLIES
liquid soap and paper towels

COMPANY KEPT
enjoying a cold beer while trying
to catch a 2nd wind, 'oh what a
night' plays on the radio

WEATHER
warm, humid
78°f/25°c afternoon

DISTANCE
3,724mi/5,994km from london,
england (a 7h 33m flight)

GOOSKI'S

40°27'24.5"N / 79°57'59.4"W

STREET ADDRESS
3117 brereton street

CITY
pittsburgh, pa

DAY OF THE WEEK
thursday

LIQUID CONSUMED
east end brewing
big hop – 2 pints;
pbr – 2 16oz cans (tall boys)

TIME OF DAY
10:18pm edt/02:18 gmt

TIME SPENT AT URINAL
19 mississippi

HANDWASHING SUPPLIES
foam soap and paper towels

COMPANY KEPT
interesting convo about life
on the oil fields while enjoying
a half dozen cheddar &
cheese pierogi

WEATHER
partly cloudy 71°f/21°c
pittsburgh night

DISTANCE
2,661mi/4,282km from
vancouver, bc (a 40h 28m drive)

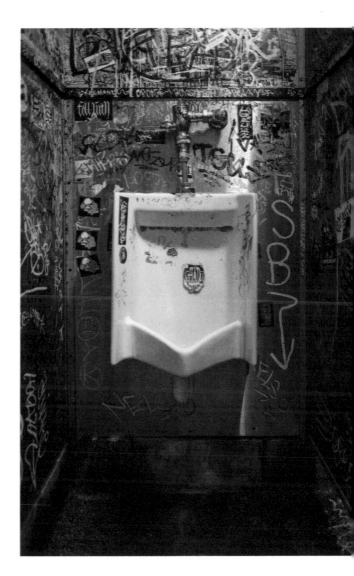

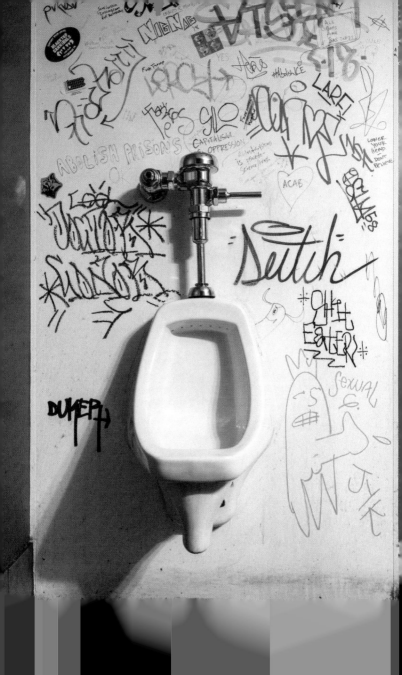

ESPRESSO A MANO

40°27'57.7"N / 79°57'54.5"W

STREET ADDRESS
3623 butler street

CITY
pittsburgh, pa

DAY OF THE WEEK
saturday

LIQUID CONSUMED
cold brew - 16oz

TIME OF DAY
10:51am edt/14:51 gmt

TIME SPENT AT URINAL
21 mississippi

HANDWASHING SUPPLIES
foam soap and a high
speed xlerator hand dryer

COMPANY KEPT
enjoyed a delicious banana
muffin while reflecting on a
different time at an old favorite

WEATHER
partly cloudy, warm
72°f/22°c morning

DISTANCE
4,228mi/6,804km from
turin, italy (a 8h 32m flight)

STREET ADDRESS
4306 butler street

CITY
pittsburgh, pa

DAY OF THE WEEK
friday

LIQUID CONSUMED
tröegs sunshine pils - 2 pints

TIME OF DAY
8:58pm edt/00:58 gmt

TIME SPENT AT URINAL
42 mississippi

HANDWASHING SUPPLIES
liquid soap and a blower
for hand drying

COMPANY KEPT
dinner with kristin - steak
appetizer with a chicken
leg entrée - great night
with a good friend

WEATHER
clear 73°f/22°c august night

DISTANCE
3,895mi/6,269km from the
louvre museum (a 7h 52m flight)

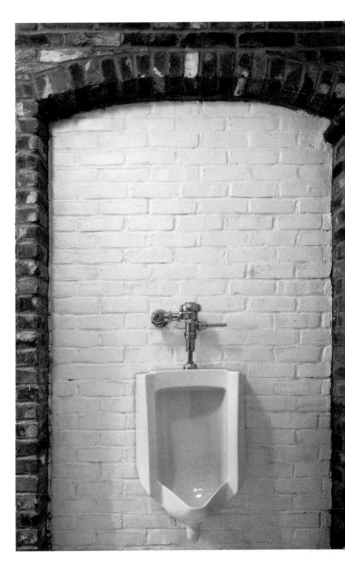

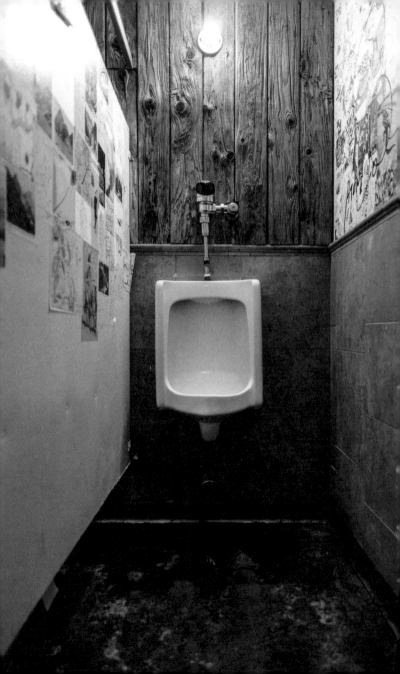

FOREST ROOM 5

39°45'28.0"N / 105°00'40.5"W

STREET ADDRESS
2532 15th street

CITY
denver, co

DAY OF THE WEEK
tuesday

LIQUID CONSUMED
odell ipa – 2 pints

TIME OF DAY
7:02pm mst/02:02 gmt

TIME SPENT AT URINAL
23 mississippi

HANDWASHING SUPPLIES
blue liquid soap in a brown
ketchup bottle and paper towels

COMPANY KEPT
talking photography with
mark over a couple beers

WEATHER
cloudy 47°f/8°c night

DISTANCE
3,936mi/6,334km from
amazonas, brasil
(an 7h 57m flight)

SUNDOWN SALOON

40°01'03.4"N / 105°16'49.0"W

STREET ADDRESS
1136 pearl street

CITY
boulder, co

DAY OF THE WEEK
sunday

LIQUID CONSUMED
pbr – 1 pitcher

TIME OF DAY
12:06am mdt/06:06 gmt

TIME SPENT AT URINAL
32 mississippi

HANDWASHING SUPPLIES
liquid soap and paper towels

COMPANY KEPT
late night pitcher and
shuffle board with jake

WEATHER
cold, snowy 29°f/-1°c
colorado night

DISTANCE
375mi/604km from deadwood,
sd (6d 2h by horseback)

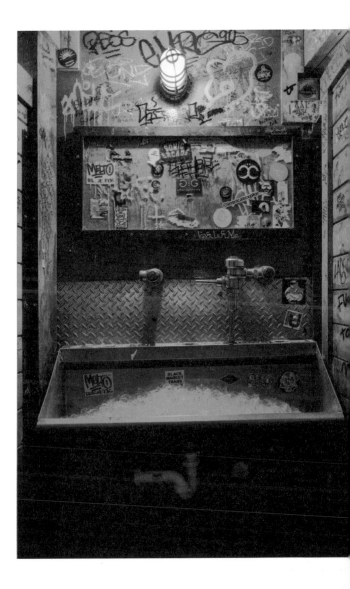

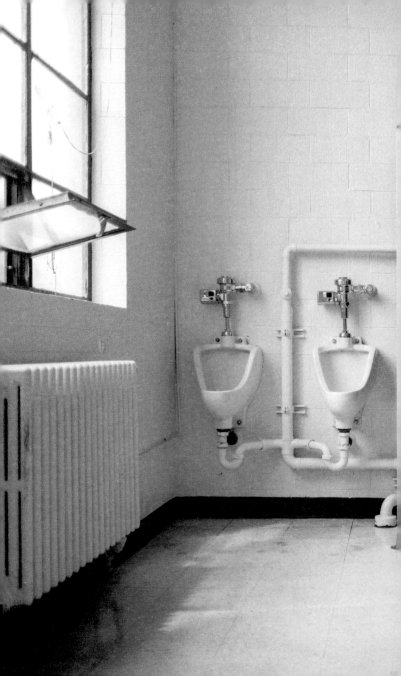

ENVIRONMENTAL DESIGN: UNIVERSITY OF COLORADO

40°00'25.5"N / 105°16'09.2"W

STREET ADDRESS
1060 18th street

CITY
boulder, co

DAY OF THE WEEK
wednesday

LIQUID CONSUMED
green tea - 12oz

TIME OF DAY
12:11pm mst/19:11 gmt

TIME SPENT AT URINAL
29 mississippi

HANDWASHING SUPPLIES
liquid soap and paper towels

COMPANY KEPT
guest lecture - talking about
doing the things you love doing

WEATHER
brisk, chilly 37°f/2°c day

DISTANCE
4,846mi/7,800km from
stockholm, sweden
(a 9h 40m flight)

HOUSE OF YES

40°42'24.4"N / 73°55'25.1"W

STREET ADDRESS
2 wyckoff avenue

CITY
brooklyn, ny

DAY OF THE WEEK
sunday

LIQUID CONSUMED
fierce grape gatorade –
1 20oz bottle

TIME OF DAY
1:18pm edt/17:18 gmt

TIME SPENT AT URINAL
16 mississippi

HANDWASHING SUPPLIES
liquid soap and paper towels

COMPANY KEPT
fun chat with hanabi about the
entertainment for the night

WEATHER
hot, sweaty 80°f/26°c afternoon

DISTANCE
4,151mi/6,681km from
florence, italy (a 8h 21m flight)

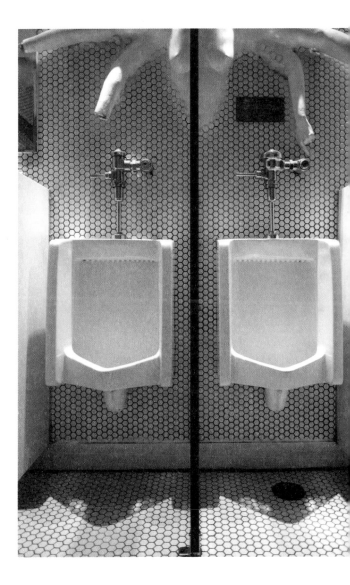

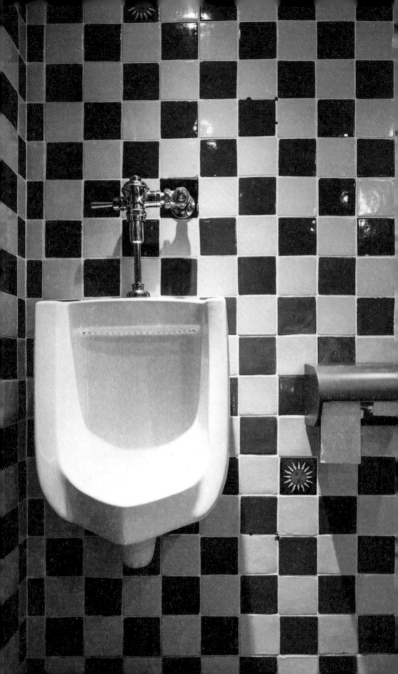

BRUNETTI

40°44'17.8"N / 74°00'19.4"W

STREET ADDRESS
626 hudson street

CITY
new york, ny

DAY OF THE WEEK
friday

LIQUID CONSUMED
gaffel kolsch - 1 pint

TIME OF DAY
11:48pm edt/03:48 gmt

TIME SPENT AT URINAL
28 mississippi

HANDWASHING SUPPLIES
liquid soap and paper towels

COMPANY KEPT
a late night funghi e cipolle
(mushroom) pie and a beer
with anna after a visit to the
whitney biennial

WEATHER
clear, cool 66°f/18°c spring night

DISTANCE
83.5m/134.4km from
westhampton, ny
(a 2h 58m train ride)

TOM & JERRY'S

40°43'28.8"N / 73°59'35.7"W

STREET ADDRESS
288 elizabeth street

CITY
new york, ny

DAY OF THE WEEK
tuesday

LIQUID CONSUMED
sixpoint the crisp pilz – 2 pints

TIME OF DAY
12:41pm est/17:41 gmt

TIME SPENT AT URINAL
26 mississippi

HANDWASHING SUPPLIES
liquid soap and paper towels

COMPANY KEPT
easy going november afternoon,
talking with stacy behind the bar

WEATHER
overcast 45°f/7°c day

DISTANCE
2,795mi/4,498km from
hollywood (a 42h 32m drive)

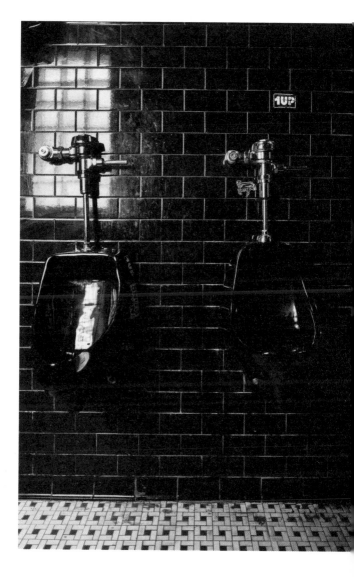

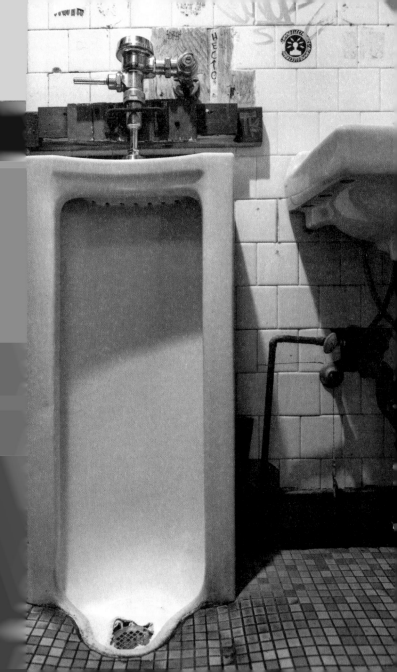

DIVE BAR

42°15'33.4"N / 71°47'52.5"W

STREET ADDRESS
34 green street

CITY
worcester, ma

DAY OF THE WEEK
friday

LIQUID CONSUMED
trillium melcher street – 1 pint;
hill farmstead edward – 1 pint;
brick & feather half-light
sunbeam – 1 pint;
oxbow bowie – 1 pint

TIME OF DAY
6:58pm est/23:58 gmt

TIME SPENT AT URINAL
32 mississippi

HANDWASHING SUPPLIES
gojo liquid soap and
paper towels

COMPANY KEPT
friendly bartender, good
night of great beer, and a
post thanksgiving fried
chicken sandwich from
mama roux parked out back

WEATHER
freezing, clear 25°f/-3°c night

DISTANCE
8,041mi/12,942km from fiji
(a 15h 43m flight)

MUSEUM OF CONTEMPORARY ART

39°45'08.2"N / 105°00'15.1"W

STREET ADDRESS
1485 delgany street

CITY
denver, co

DAY OF THE WEEK
friday

LIQUID CONSUMED
a visit to the water fountain

TIME OF DAY
12:44pm mdt/18:44 gmt

TIME SPENT AT URINAL
16 mississippi

HANDWASHING SUPPLIES
liquid soap and paper towels

COMPANY KEPT
taking in one last viewing of
arthur jafa's powerful film
'love is the message, the
message is death'

WEATHER
cloudy 73°f/22°c afternoon

DISTANCE
1,217mi/1,959km
from los angeles, ca
(a 19d 8h bike ride)

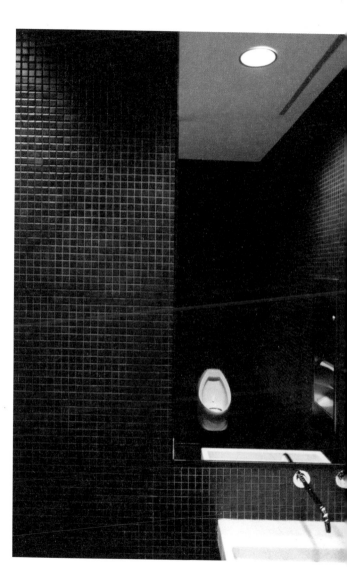

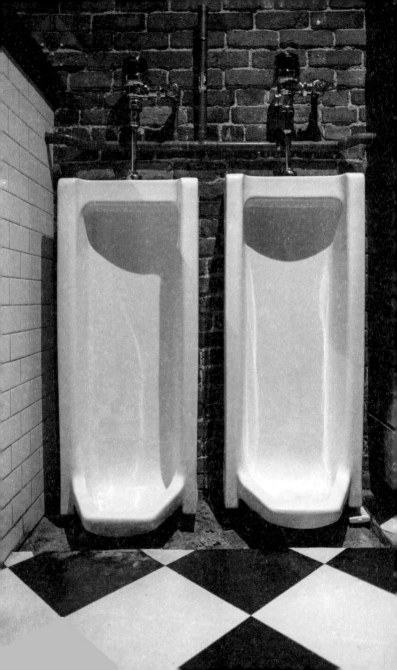

STODDARDS FINE FOOD & ALE

42°21'18.7"N / 71°03'41.9"W

STREET ADDRESS
48 temple place

CITY
boston, ma

DAY OF THE WEEK
thursday

LIQUID CONSUMED
maine beer company
water & woods ipa – 1 pint

TIME OF DAY
1:11pm edt/17:11 gmt

TIME SPENT AT URINAL
17 mississippi

HANDWASHING SUPPLIES
deb liquid soap and
paper towels

COMPANY KEPT
grabbing a beer and anticipating
a great weekend of music
in newport for folk fest

WEATHER
cloudy 80°f/26°c
boston afternoon

DISTANCE
78.2mi/125.9km from fort adams
state park (a 1h 47m drive)

STREET ADDRESS
200 broadway

CITY
newport, ri

DAY OF THE WEEK
friday

LIQUID CONSUMED
whalers rise pale ale – 4 pints

TIME OF DAY
11:17pm edt/03:17 gmt

TIME SPENT AT URINAL
31 mississippi

HANDWASHING SUPPLIES
liquid soap and paper towels

COMPANY KEPT
taking in a night of good
music from charley crockett
and his friends along side
kala, jay, and nick

WEATHER
clear, beautiful 70°f/21°c night

DISTANCE
2,140mi/3,444km from san
benito, tx (a 33h 19m drive)

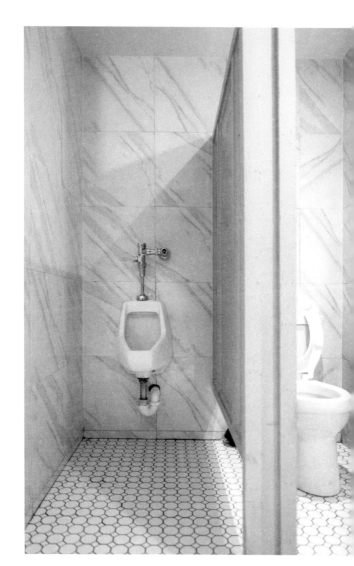

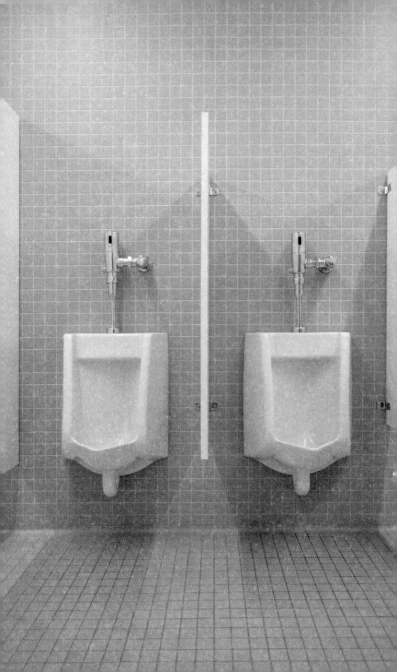

ICA WATERSHED

42°21'48.8"N / 71°01'59.9"W

STREET ADDRESS
 256 marginal street

CITY
 east boston, ma

DAY OF THE WEEK
 wednesday

LIQUID CONSUMED
 multiple drinks from
 the water fountain

TIME OF DAY
 3:28pm edt/19:28 gmt

TIME SPENT AT URINAL
 19 mississippi

HANDWASHING SUPPLIES
 liquid soap and paper towels

COMPANY KEPT
 watching johan akomfrag's
 film 'purple', feeling
 inspired and calm

WEATHER
 cloudy, comfortable
 77°f/25°c afternoon

DISTANCE
 2,322mi/3,738km from
 greenland (a 3d 10h boat ride)

STANDINGS

40°43'41.9"N / 73°59'18.9"W

STREET ADDRESS
43 east 7th street

CITY
new york, ny

DAY OF THE WEEK
sunday

LIQUID CONSUMED
lagunitas pils – 1 pint

TIME OF DAY
10:32pm edt/02:32 gmt

TIME SPENT AT URINAL
24 mississippi

HANDWASHING SUPPLIES
liquid soap and paper towels

COMPANY KEPT
catching last call, chatting
with bartender sam

WEATHER
overcast 73°f/22°c night

DISTANCE
9.3mi/14.9km from yankee
stadium (a 36m subway ride)

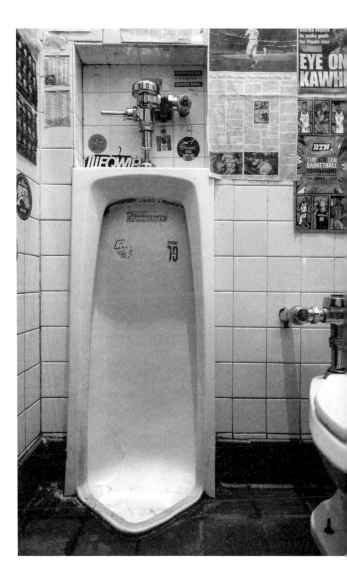

MANCHESTE
RAYÍSTAS
QUINCE AÑO

PIKELAND Pils

Cricket Hill
BARREL AGED
PORTER

More Giants / P. 49

...Pete is on pace to hit 35 home runs this season, which would break Aaron Judge's major league record for homers by a rookie. Also on's home runs travel an average of 410 feet.

York's Rising Star? Here Comes the Polar Bear

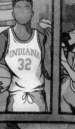

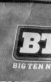

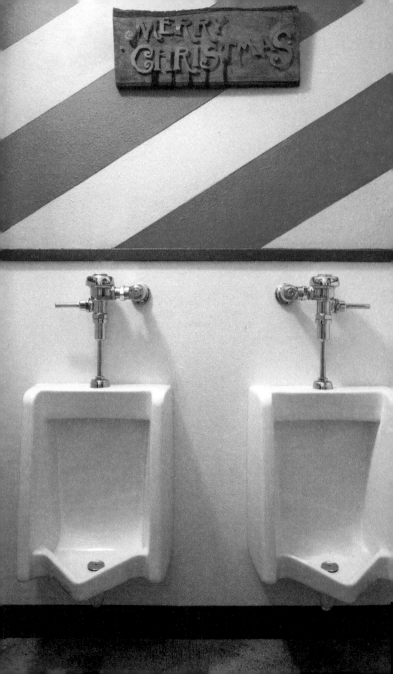

LALA'S LITTLE NUGGET

30°20'40.3"N / 97°44'10.3"W

STREET ADDRESS
2207 justin lane

CITY
austin, tx

DAY OF THE WEEK
saturday

LIQUID CONSUMED
lone star lager – 3 16oz
cans (tall boys)

TIME OF DAY
10:56pm cdt/03:56 gmt

TIME SPENT AT URINAL
27 mississippi

HANDWASHING SUPPLIES
gojo foam soap and
paper towels

COMPANY KEPT
festive night with burg
and charlie

WEATHER
clear, warm 82°f/27°c night

DISTANCE
4,481mi/7,211km from the
north pole (a 8h 45m flight)

POOL BURGER

30°16'39.9"N / 97°46'21.5"W

STREET ADDRESS
2315 lake austin boulevard

CITY
austin, tx

DAY OF THE WEEK
saturday

LIQUID CONSUMED
arrowhead spring water –
1 1.5l bottle

TIME OF DAY
3:58pm cdt/20:58 gmt

TIME SPENT AT URINAL
17 mississippi

HANDWASHING SUPPLIES
liquid soap and paper towels

COMPANY KEPT
quick stop after a day of
swimming at deep eddy
pool with charlie and lauren

WEATHER
hot, humid 92°f/33°c afternoon

DISTANCE
0.2mi/0.3km from deep
eddy pool (a 3m walk)

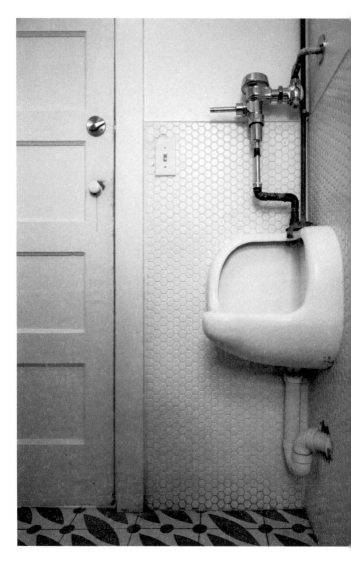

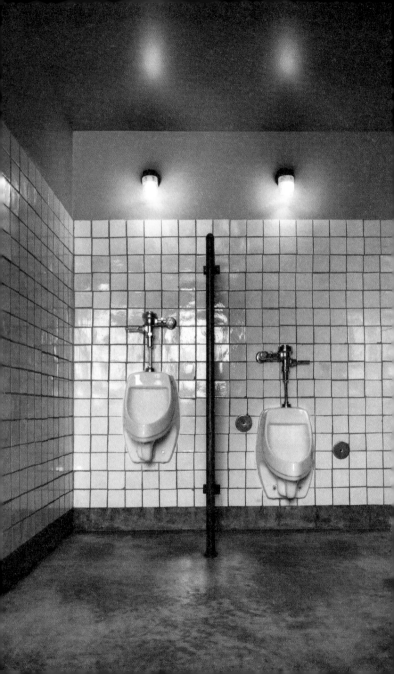

WHISLER'S

30°15'43.1"N / 97°43'21.8"W

STREET ADDRESS
1816 east 6th street

CITY
austin, tx

DAY OF THE WEEK
friday

LIQUID CONSUMED
han's pils – 1 12oz can

TIME OF DAY
4:17pm cdt/21:17 gmt

TIME SPENT AT URINAL
17 mississippi

HANDWASHING SUPPLIES
pink liquid soap and
paper towels

COMPANY KEPT
meeting up with charlie
before heading over to
the scoot inn for glorietta

WEATHER
overcast 74°f/23°c spring night

DISTANCE
0.5mi/0.8km from the
scoot inn (an 11m walk)

DEEP EDDY CABARET

30°16'40.3"N / 97°46'21.2"W

STREET ADDRESS
2315 lake austin boulevard

CITY
austin, tx

DAY OF THE WEEK
saturday

LIQUID CONSUMED
lone star lager – 2 12oz bottles

TIME OF DAY
5:52pm cdt/22:52 gmt

TIME SPENT AT URINAL
25 mississippi

HANDWASHING SUPPLIES
liquid soap and an all natural
air dry (no towels)

COMPANY KEPT
post swim beers with
charlie, feeling refreshed,
talk of bbq for dinner,
great summer day in texas

WEATHER
hot 94°f/34°c evening

DISTANCE
5,102mi/8,212km from moulin
rouge (a 10h 9m flight)

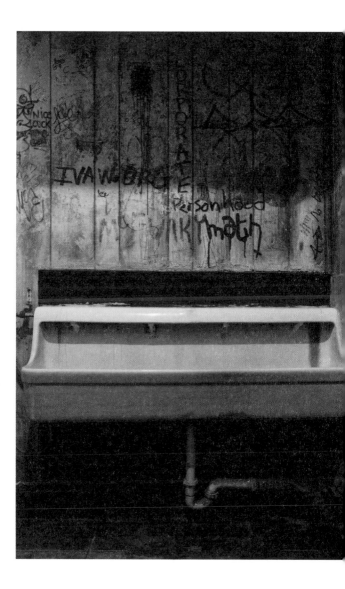

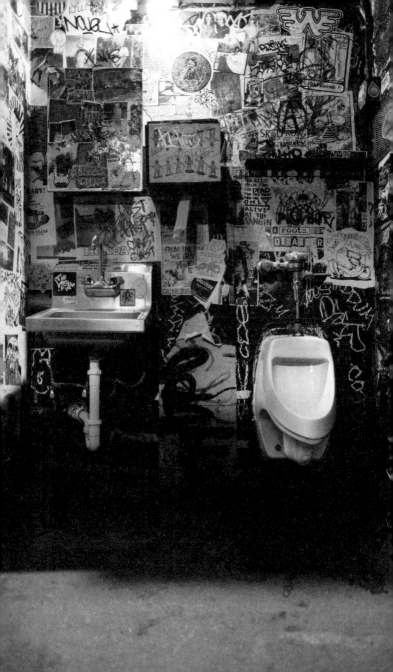

YELLOW JACKET SOCIAL CLUB

30°15'42.2"N / 97°43'29.2"W

STREET ADDRESS
1704 east 5th street

CITY
austin, tx

DAY OF THE WEEK
friday

LIQUID CONSUMED
modelo – 2 pints

TIME OF DAY
1:59pm cdt/18:59 gmt

TIME SPENT AT URINAL
22 mississippi

HANDWASHING SUPPLIES
liquid soap and paper towels

COMPANY KEPT
lunchtime break with a bar
tender recommended beet
sandwich + a bacon add on

WEATHER
hot, sticky 91°f/32°c afternoon

DISTANCE
4,732mi/7,616km from santiago,
chile (a 9h 27m flight)

MIRÓ RIVERA TRAIL

30°15'20.0"N / 97°44'23.3"W

STREET ADDRESS
cummings street

CITY
austin, tx

DAY OF THE WEEK
sunday

LIQUID CONSUMED
cold brew - 16oz

TIME OF DAY
10:26am cdt/15:26 gmt

TIME SPENT AT URINAL
17 mississippi

HANDWASHING SUPPLIES
bar soap and natural
air dry (no towels)

COMPANY KEPT
nice morning walk
along lady bird lake

WEATHER
partly cloudy, warm
84°f/28°c austin morning

DISTANCE
2.6mi/4.2km from
zilker park (a 51m walk)

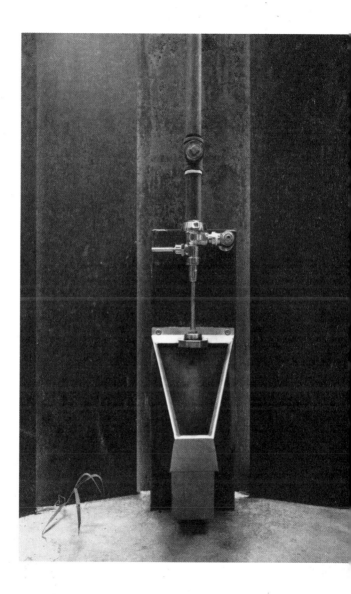

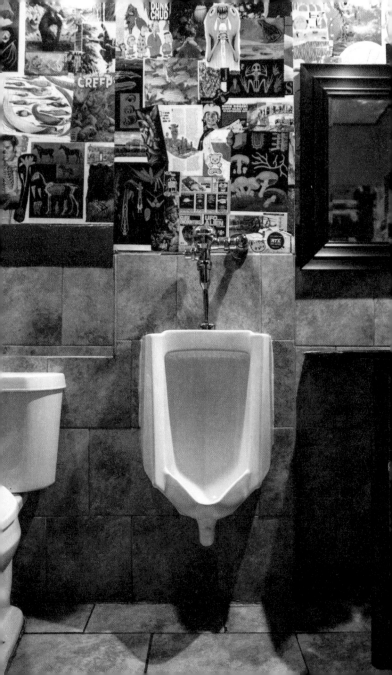

FRAZIER'S LONG & LOW

30°14'21.4"N / 97°43'11.6"W

STREET ADDRESS
2538 elmont drive

CITY
austin, tx

DAY OF THE WEEK
sunday

LIQUID CONSUMED
austin beer works
pearl snap – 2 pints

TIME OF DAY
12:14pm cdt/17:14 gmt

TIME SPENT AT URINAL
21 mississippi

HANDWASHING SUPPLIES
foam soap and paper towels

COMPANY KEPT
fun bartenders and a
complimentary and tasty
chopped cheese (burger)

WEATHER
a very hot 93°f/33°c afternoon

DISTANCE
2,123mi/3,417km from
the seattle space needle
(a 33h 12m drive)

THE HOLE IN THE WALL

30°17'24.3"N / 97°44'31.1"W

STREET ADDRESS
2538 guadalupe street

CITY
austin, tx

DAY OF THE WEEK
sunday

LIQUID CONSUMED
lone star lager – 2 12oz cans

TIME OF DAY
6:59pm cdt/23:59 gmt

TIME SPENT AT URINAL
18 mississippi

HANDWASHING SUPPLIES
7-eleven liquid soap
and paper towels

COMPANY KEPT
exploring this legendary venue
where musicians such as gary
clark jr. honed his chops, and
where david byrne once cut
up the dance floor

WEATHER
hot 94°f/34°c early evening

DISTANCE
7,486mi/12,048km from
the great wall of china
(a 15h 28m flight)

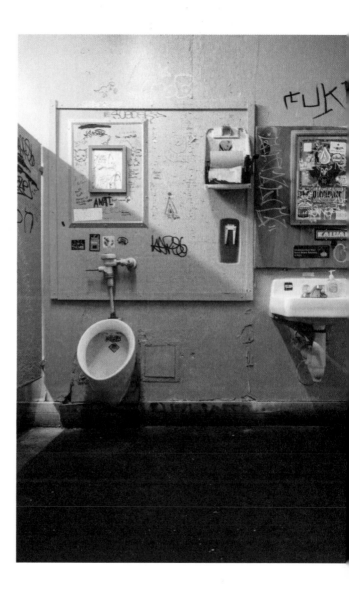

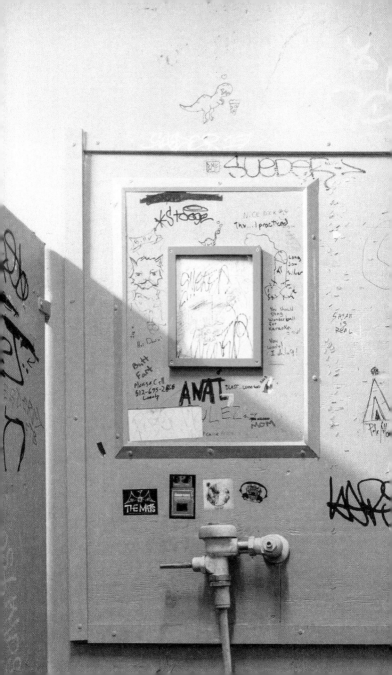

COME AND TAKE IT!

brilliant.

TUPPS
BREWERY

Employees Must Wash
Hands Before Returning
to Work

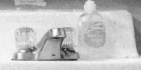

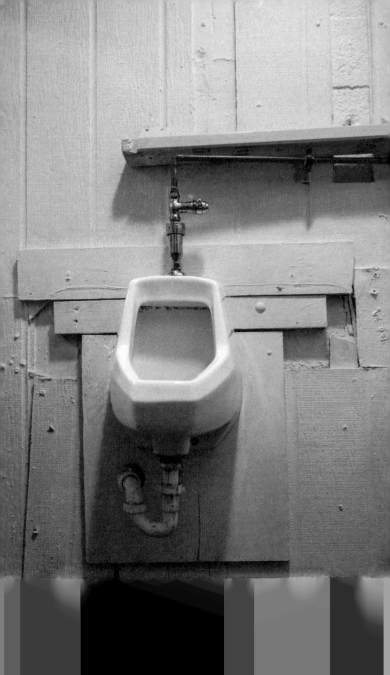

THE ARISTOCRAT LOUNGE

30°20'25.0"N / 97°44'18.8"W

STREET ADDRESS
6507 burnet road

CITY
austin, tx

DAY OF THE WEEK
sunday

LIQUID CONSUMED
lone star lager –
1 16oz can (tall boy)

TIME OF DAY
8:18pm cdt/01:18 gmt

TIME SPENT AT URINAL
22 mississippi

HANDWASHING SUPPLIES
pink liquid soap and
paper towels

COMPANY KEPT
solo wind down with a cold beer
at the bar to end a long, hot day

WEATHER
hot, humid 92°f/33°c evening

DISTANCE
5,103mi/8,212km from the
eiffel tower (a 10h 9m flight)

TROOP

41°49'09.2"N / 71°26'26.6"W

STREET ADDRESS
60 valley street

CITY
providence, ri

DAY OF THE WEEK
tuesday

LIQUID CONSUMED
grey sail captain's
daughter - 2 pints

TIME OF DAY
9:12pm edt/01:12 gmt

TIME SPENT AT URINAL
33 mississippi

HANDWASHING SUPPLIES
ecolab foam soap
and paper towels

COMPANY KEPT
grabbing a much needed and
delicious meal at the bar - a nice
plate of heirloom tomatoes with
pickled green peaches to start,
followed by an amazing smoked
beef rib and plantain chips

WEATHER
cloudy, damp 68°f/20°c night

DISTANCE
6,109mi/9,832km from
republic of the congo
(a 12h 4m flight)

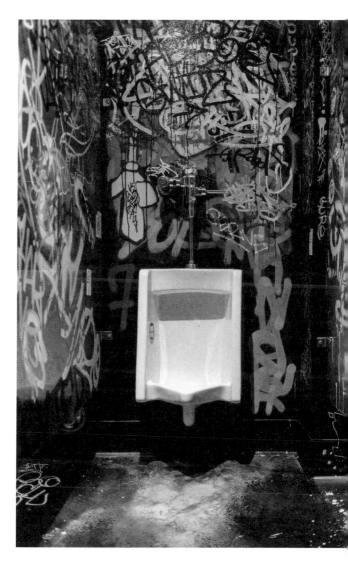

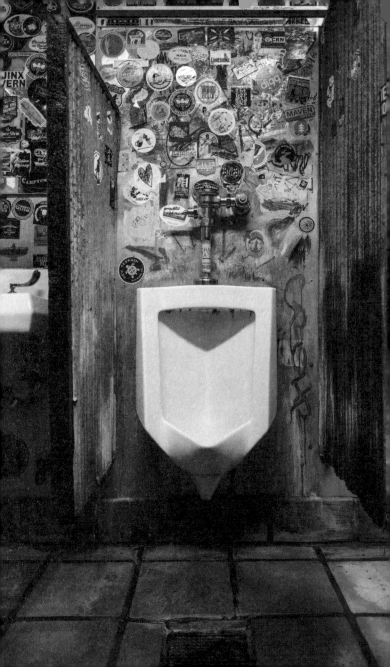

OSKAR BLUES GRILL & BREW

40°13'27.4"N / 105°16'06.8"W

STREET ADDRESS
303 main street

CITY
lyons, co

DAY OF THE WEEK
saturday

LIQUID CONSUMED
oskar blues yella pils – 3 pints

TIME OF DAY
9:37pm mdt/03:37 gmt

TIME SPENT AT URINAL
22 mississippi

HANDWASHING SUPPLIES
foam soap and paper towels

COMPANY KEPT
b.b. king burger with fries and
beers with stephen and amber

WEATHER
clear, pleasant 72°f/22°c
colorado evening

DISTANCE
1,081mi/1,740km from
memphis, tn (a 16h 34m drive)

PIE HOLE

39°42'56.7"N / 104°59'14.4"W

STREET ADDRESS
44 south broadway

CITY
denver, co

DAY OF THE WEEK
sunday

LIQUID CONSUMED
coors banquet - 1 12oz can

TIME OF DAY
12:17am mdt/06:17 gmt

TIME SPENT AT URINAL
25 mississippi

HANDWASHING SUPPLIES
orange foam soap
and paper towels

COMPANY KEPT
slice of cheese, slice of
pepperoni, and a beer with
a fun group of friends

WEATHER
clear, comfortable
70°f/21°c night

DISTANCE
550mi/885km from
old faithful (a 20d 5h hike)

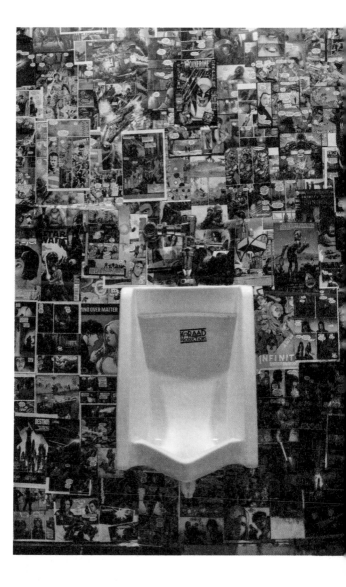

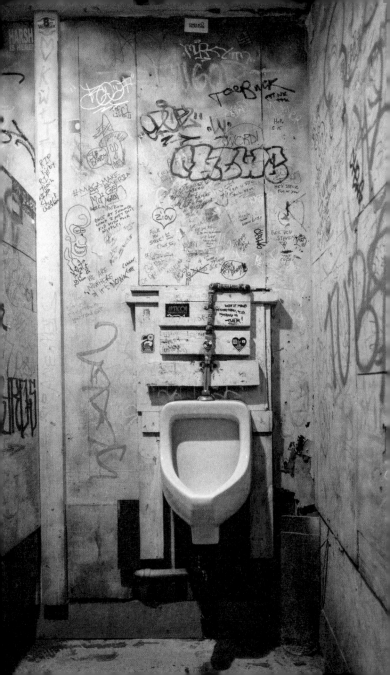

MS. MAE'S

29°55'14.6"N / 90°06'04.5"W

STREET ADDRESS
4336 magazine street

CITY
new orleans, la

DAY OF THE WEEK
friday

LIQUID CONSUMED
pbr – 4 pints

TIME OF DAY
1:59pm cdt/18:59 gmt

TIME SPENT AT URINAL
39 mississippi

HANDWASHING SUPPLIES
liquid soap and high speed
xlerator hand dryer

COMPANY KEPT
afternoon of pulp fiction on
the tv, conversation about
classic movies, and a great list
of restaurant recommendations
from the bartender and
the friendly locals

WEATHER
humid, hot 91°f/32°c day

DISTANCE
3.2mi/5.1km from
jacques-imo's (a 1h 5m walk)

SNAKE & JAKE'S CHRISTMAS CLUB LOUNGE

29°56'38.9"N / 90°07'33.8"W

STREET ADDRESS
7612 oak street

CITY
new orleans, la

DAY OF THE WEEK
friday

LIQUID CONSUMED
miller lite – 4 12oz bottles

TIME OF DAY
11:55pm cdt/04:55 gmt

TIME SPENT AT URINAL
31 mississippi

HANDWASHING SUPPLIES
liquid soap and paper towels

COMPANY KEPT
sweaty night enjoying the
neighborhood vibes of this
delightful new orleans dive with
bartender juan and his dog

WEATHER
a hot, very humid
86°f/30°c evening

DISTANCE
1,315mi/2,116km from
rockefeller center
(a 19h 36m drive)

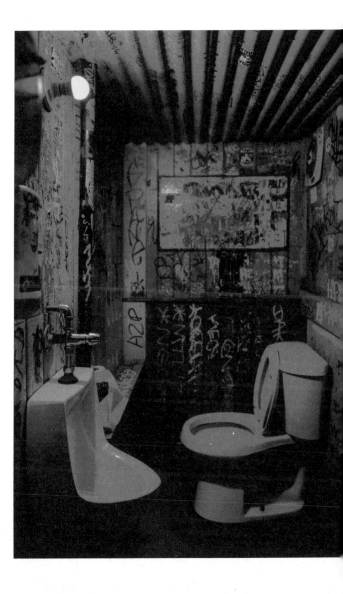

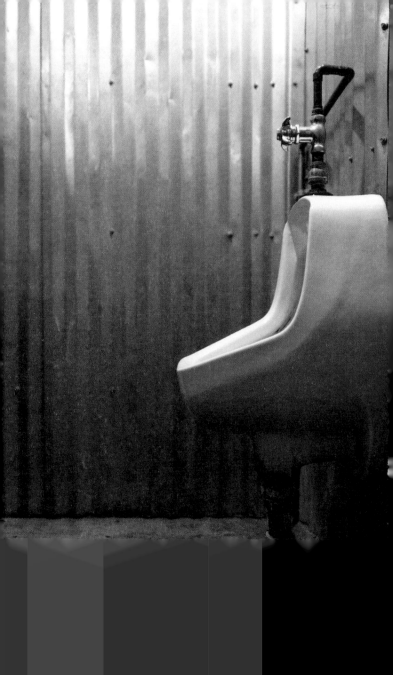

BJ'S LOUNGE

29°57'46.3"N / 90°01'59.1"W

STREET ADDRESS
4301 burgundy street

CITY
new orleans, la

DAY OF THE WEEK
sunday

LIQUID CONSUMED
pbr – 3 12oz bottles;
jameson – 2 shots

TIME OF DAY
2:08am cdt/07:08 gmt

TIME SPENT AT URINAL
21 mississippi

HANDWASHING SUPPLIES
softsoap liquid soap
and paper towels

COMPANY KEPT
a great chat with bartender troy
about local music, the saints,
teaching, and other random
things, a bar i will surely return to

WEATHER
a humid 85°f/29°c late
night/early morning

DISTANCE
2,012mi/3,239km from caracas,
venezuela (a 4h 18m flight)

J&J'S SPORTS LOUNGE

29°57'43.8"N / 90°02'04.6"W

STREET ADDRESS
800 france street

CITY
new orleans, la

DAY OF THE WEEK
saturday

LIQUID CONSUMED
modelo – 1 16oz can (tall boy)

TIME OF DAY
12:41pm cdt/17:41 gmt

TIME SPENT AT URINAL
21 mississippi

HANDWASHING SUPPLIES
softsoap liquid soap
and paper towels

COMPANY KEPT
a quiet early afternoon with
a cold beer on an extremely
hot day, watching the local
new orleans news

WEATHER
a feels like 100° – 87°f/30°c
new orleans afternoon

DISTANCE
2,222mi/3,576km from the
equator (a 4h 42m flight)

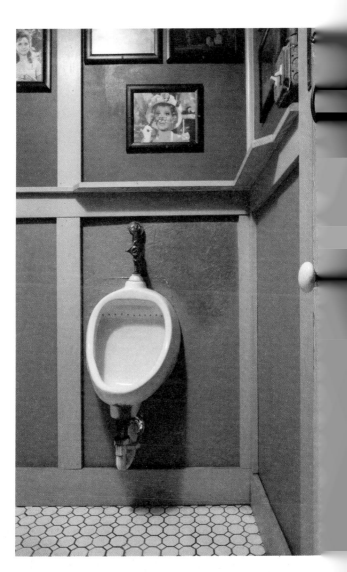

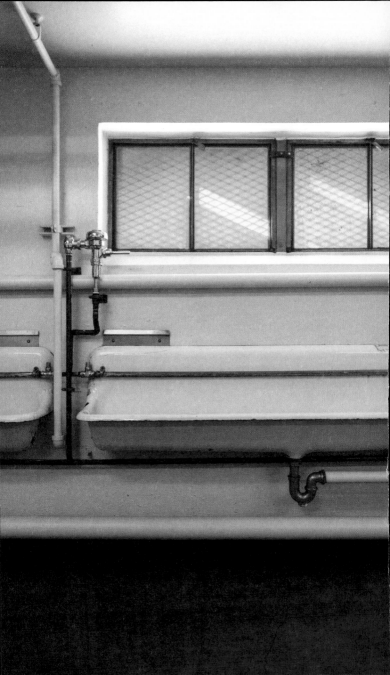

FOLSOM FIELD

40°00'33.7"N / 105°16'00.8"W

STREET ADDRESS
2400 colorado avenue

CITY
boulder, co

DAY OF THE WEEK
saturday

LIQUID CONSUMED
coors banquet – 6 16oz
cans (tall boys)

TIME OF DAY
4:52pm mdt/22:52 gmt

TIME SPENT AT URINAL
33 mississippi

HANDWASHING SUPPLIES
liquid soap and paper towels

COMPANY KEPT
game day with friends, 5:48
left in the 3rd quarter, colorado
down 21-20 to arizona

WEATHER
clear, beautiful 65°f/18°c
fall afternoon

DISTANCE
921mi/1482km from
tucson, az (a 13h 39m drive)

UFO FACTORY

42°19'55.8"N / 83°04'01.4"W

STREET ADDRESS
2110 trumbull

CITY
detroit, mi

DAY OF THE WEEK
saturday

LIQUID CONSUMED
pbr - 2 pints

TIME OF DAY
9:52pm est/02:52 gmt

TIME SPENT AT URINAL
21 mississippi

HANDWASHING SUPPLIES
foam soap and a high speed
extreme hand dryer

COMPANY KEPT
immersed myself into a living
art installation, from the loud
rock of the stools, to the
amazing 'ufo bathroom' by
davin brainard and dion fischer

WEATHER
frigid 36°f/2°c detroit night

DISTANCE
1,493mi/2,402km from
roswell, nm (a 22h 28m drive)

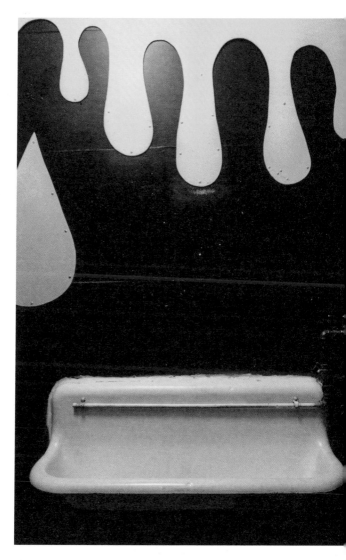

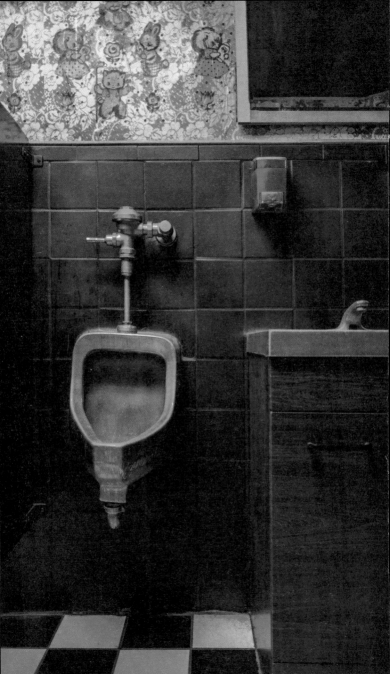

THE HIGH DIVE

42°24'06.4"N / 83°03'39.3"W

STREET ADDRESS
11474 joseph campau avenue

CITY
hamtramck, mi

DAY OF THE WEEK
sunday

LIQUID CONSUMED
pbr – 2 16oz cans (tall boys)

TIME OF DAY
8:12pm est/01:12 gmt

TIME SPENT AT URINAL
22 mississippi

HANDWASHING SUPPLIES
green liquid soap and a
gentle golden hand dryer

COMPANY KEPT
good convo with bar tender
and owner shark toof, funky
music, and great vibes

WEATHER
cold, cloudy 43°f/6°c night

DISTANCE
8,294mi/13,348km from
cape town, south africa
(a 16h 12m flight)

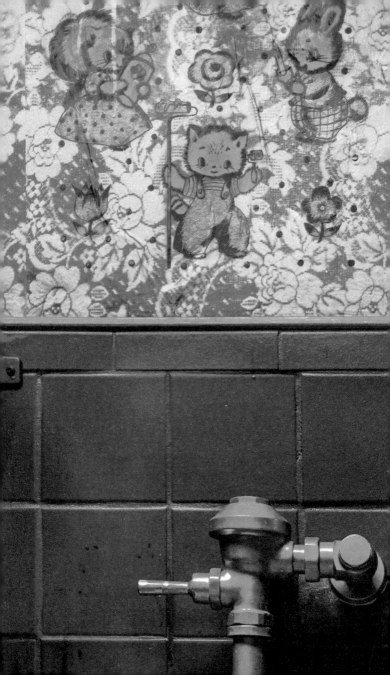

DONOVAN'S PUB

42°19'31.4"N / 83°04'56.9"W

STREET ADDRESS
3003 vernor highway

CITY
detroit, mi

DAY OF THE WEEK
saturday

LIQUID CONSUMED
pbr - 1 12oz bottle

TIME OF DAY
11:04pm est/04:04 gmt

TIME SPENT AT URINAL
25 mississippi

HANDWASHING SUPPLIES
foam soap and paper towels

COMPANY KEPT
discovering the music
of jo rad silver

WEATHER
cold 36°f/2°c detroit night

DISTANCE
3,408mi/5,484km from the
blarney stone (a 6h 57m flight)

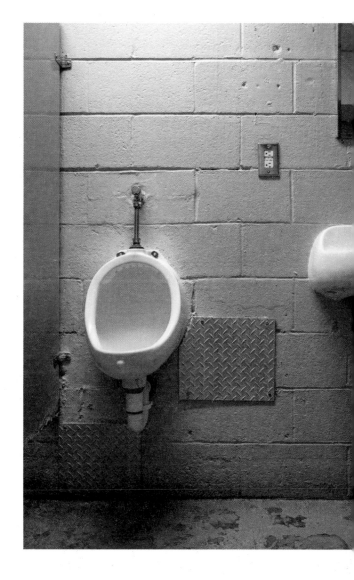

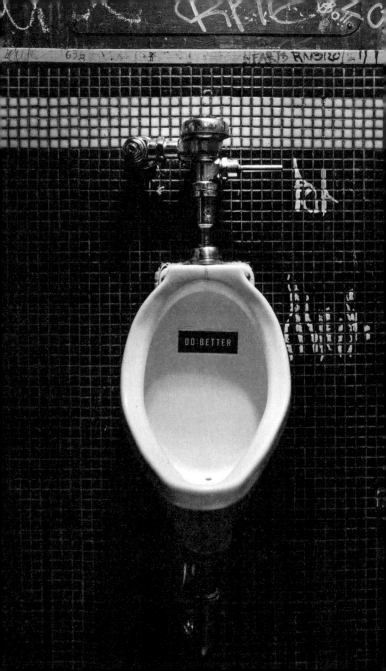

BRONX BAR

42°21'08.1"N / 83°04'00.9"W

STREET ADDRESS
4476 2nd avenue

CITY
detroit, mi

DAY OF THE WEEK
sunday

LIQUID CONSUMED
brooklyn lager – 2 pints

TIME OF DAY
12:44am est/05:44 gmt

TIME SPENT AT URINAL
26 mississippi

HANDWASHING SUPPLIES
pink liquid soap and
a strong air dryer

COMPANY KEPT
grabbed a spot at the bar for
a late night snack (french fries),
good jams on the radio

WEATHER
cloudy, cold 33°F/0°C night

DISTANCE
616mi/991km from the
george washington bridge
(a 9h 32m drive)

ABICK'S BAR

42°19'37.0"N / 83°07'07.5"W

STREET ADDRESS
3500 gilbert street

CITY
southwest detroit, mi

DAY OF THE WEEK
sunday

LIQUID CONSUMED
modelo – 1 12oz bottle

TIME OF DAY
6:44pm est/23:44gmt

TIME SPENT AT URINAL
26 mississippi

HANDWASHING SUPPLIES
foam soap with continuous
roll hand towel for drying

COMPANY KEPT
friendly conversation with the
bar tender katherine revolving
around ghosts and haunted
establishments in detroit while
watching bradley cooper in
american sniper with eric
and his dog shadow

WEATHER
partly cloudy, chilly
42°f/5°c evening

DISTANCE
628mi/1,010km from sleepy
hollow, ny (a 20h 21m train ride)

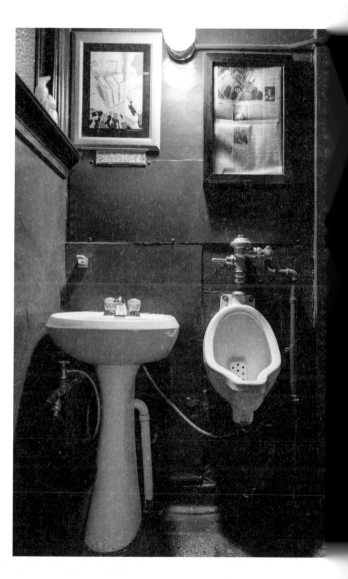

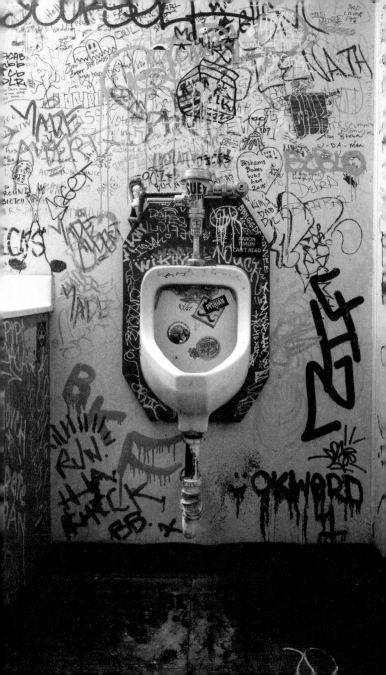

KELLY'S BAR

42°23'31.1"N / 83°03'35.2"W

STREET ADDRESS
2403 holbrook avenue

CITY
hamtramck, mi

DAY OF THE WEEK
sunday

LIQUID CONSUMED
pbr - 1 16oz can (tall boy)

TIME OF DAY
10:19pm est/03:19 gmt

TIME SPENT AT URINAL
17 mississippi

HANDWASHING SUPPLIES
dial moisturizing hand
soap and paper towels

COMPANY KEPT
quiet easy going sunday night,
friendly convo with the bartender

WEATHER
mostly cloudy, chilly
42°f/5°c night

DISTANCE
386mi/621km from niagara falls
(an 18h 4m bus ride)

TATTOOED MOM: DOWNSTAIRS

39°56'30.7"N / 75°09'06.8"W

STREET ADDRESS
530 south street

CITY
philadelphia, pa

DAY OF THE WEEK
tuesday

LIQUID CONSUMED
pbr – 2 16oz cans (tall boys)

TIME OF DAY
1:56pm est/18:56 gmt

TIME SPENT AT URINAL
21 mississippi

HANDWASHING SUPPLIES
meyer lemon (green) liquid
soap and paper towels

COMPANY KEPT
lunch time taco special,
thanksgiving edition (oven
roasted chicken, brussels
sprout slaw, cranberry crema)
accompanied by talk of
cleveland with the bartender
and fellow patrons

WEATHER
clear, warm 59°f/15°c
fall afternoon

DISTANCE
134mi/215km from annapolis,
md (an 11h 22m bike ride)

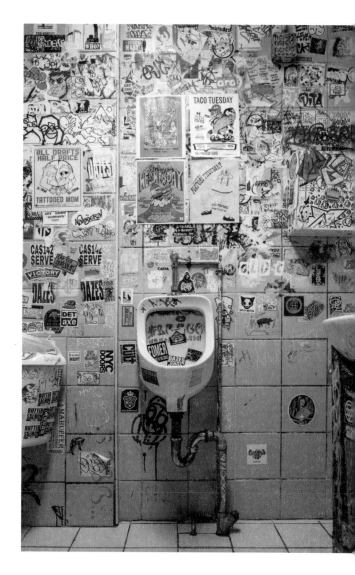

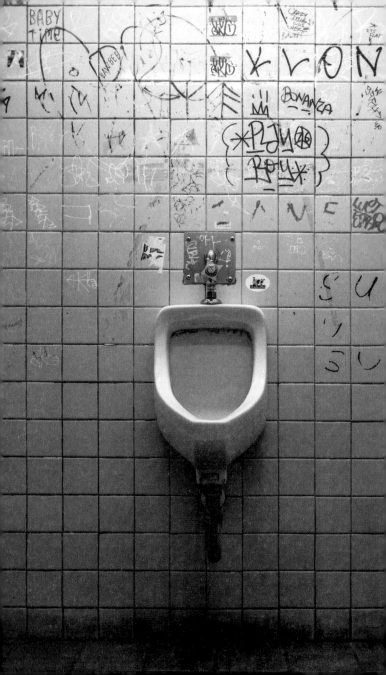

DIRTY FRANKS

39°56'43.3"N / 75°09'46.0"W

STREET ADDRESS
347 south 13th street

CITY
philadelphia, pa

DAY OF THE WEEK
tuesday

LIQUID CONSUMED
pbr – 1 16oz can (tall boy)

TIME OF DAY
12:10pm est/17:10 gmt

TIME SPENT AT URINAL
19 mississippi

HANDWASHING SUPPLIES
meyer lemon (yellow) liquid
soap and paper towels

COMPANY KEPT
quiet pre-thanksgiving
afternoon, casual conversation
with the bar tender and
owner while heat of the
night played on the tv

WEATHER
unseasonably warm, sunny
59°f/15°c november day

DISTANCE
92.6mi/149.1km from
hoboken, nj (a 3d 9h walk)

TATTOOED MOM: UPSTAIRS

39°56'30.7"N / 75°09'06.8"W

STREET ADDRESS
530 south street

CITY
philadelphia, pa

DAY OF THE WEEK
tuesday

LIQUID CONSUMED
pbr – 3 16oz cans (tall boys)

TIME OF DAY
10:02pm est/03:02 gmt

TIME SPENT AT URINAL
27 mississippi

HANDWASHING SUPPLIES
berry delicious (red) liquid
soap and paper towels

COMPANY KEPT
back for round 2 to experience
and explore the eclectic upstairs
of this wonderful watering hole,
good vibes with good folks

WEATHER
clear, comfortable
56°f/13°c evening

DISTANCE
5,188mi/8,350km from crete,
greece (a 10h 18m flight)

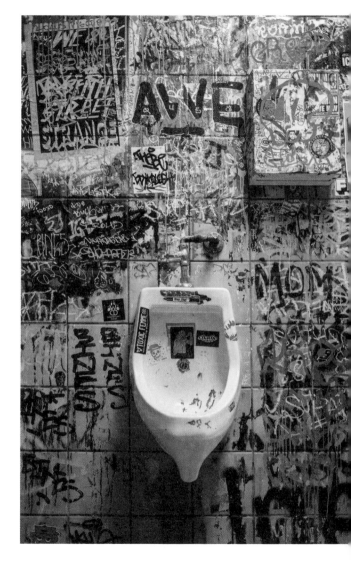

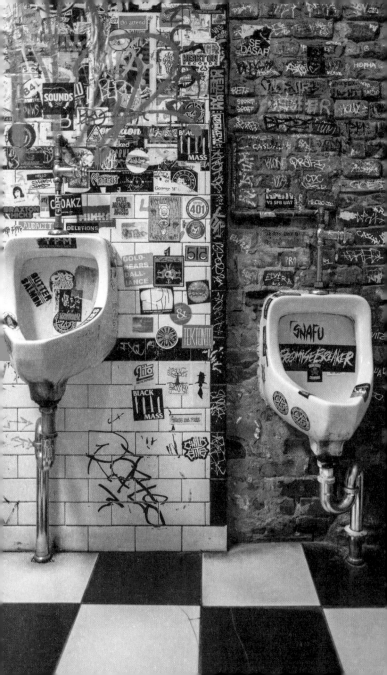

KUNG FU NECKTIE

39°58'13.0"N / 75°08'09.4"W

STREET ADDRESS
1248 north front street

CITY
philadelphia, pa

DAY OF THE WEEK
tuesday

LIQUID CONSUMED
modelo – 1 pint

TIME OF DAY
10:36pm est/03:36 gmt

TIME SPENT AT URINAL
26 mississippi

HANDWASHING SUPPLIES
purple liquid soap
and paper towels

COMPANY KEPT
ending the night with a
little heavy metal karaoke

WEATHER
clear, cool 55°f/12°c night

DISTANCE
6,886mi/11,083km from
forbidden city (a 13h 32m flight)

SAINT LAZARUS

39°58'07.5"N 75°08'11.1"W

STREET ADDRESS
102 west girard avenue

CITY
philadelphia, pa

DAY OF THE WEEK
wednesday

LIQUID CONSUMED
pbr – 3 16oz cans (tall boys)

TIME OF DAY
6:24pm est/23:24gmt

TIME SPENT AT URINAL
26 mississippi

HANDWASHING SUPPLIES
orange liquid soap and a
slow gentle hand dryer

COMPANY KEPT
thanksgiving eve with
some dance music before
the feast to come

WEATHER
cloudy, cool 57°f/13°c night

DISTANCE
4,376m/7,043km from the
vatican (a 8h 47m flight)

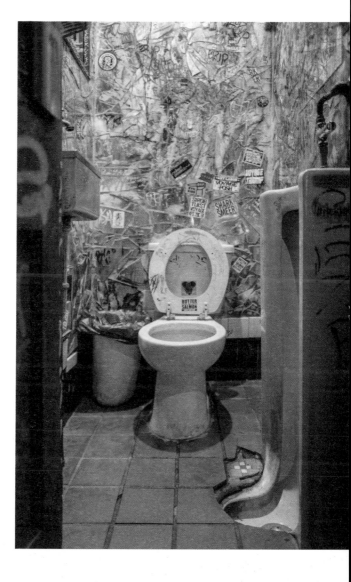

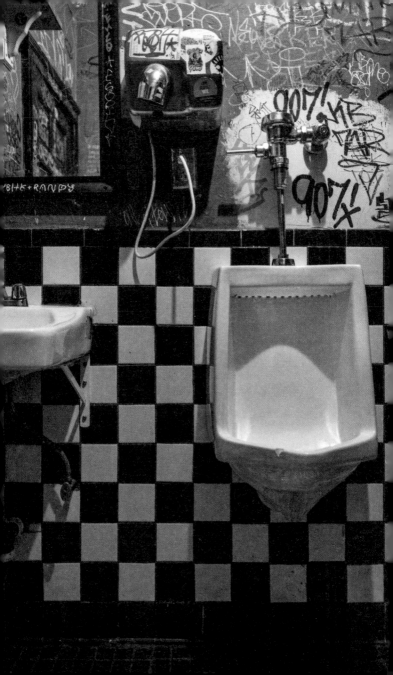

ALIBI

40°41'21.7"N / 73°58'10.2"W

STREET ADDRESS
242 dekalb avenue

CITY
brooklyn, ny

DAY OF THE WEEK
sunday

LIQUID CONSUMED
budweiser - 2 12oz bottles

TIME OF DAY
2:02pm est/19:02 gmt

TIME SPENT AT URINAL
18 mississippi

HANDWASHING SUPPLIES
rose petal liquid soap
and an auto hand dryer

COMPANY KEPT
casual sunday, taking it
slow, watching the steelers
play the jets on the tv

WEATHER
sunny, cool 44°f/6°c afternoon

DISTANCE
3,075m/4,948km from alcatraz
island (a 3d 4h bus ride)

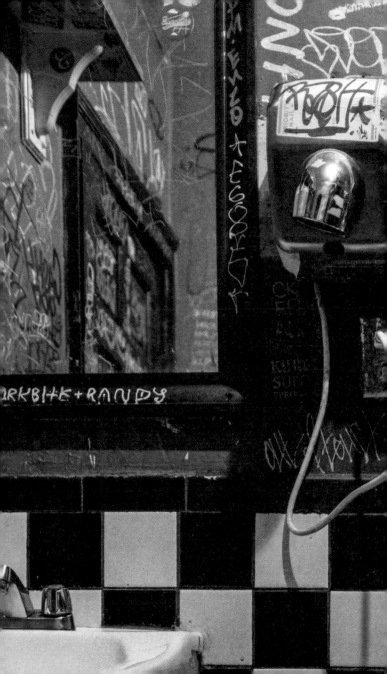

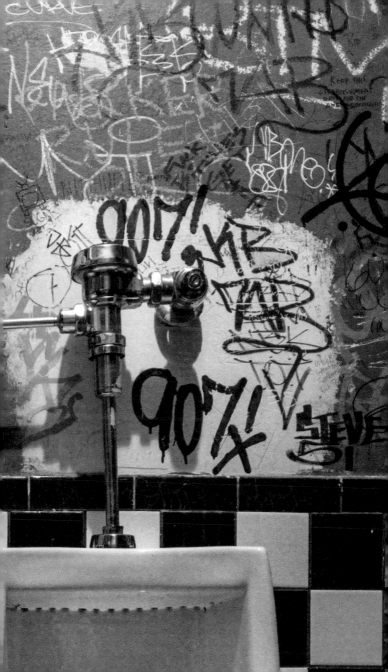

OUTER LIMITS LOUNGE

42°24'16.8"N / 83°02'49.3"W

STREET ADDRESS
5507 caniff street

CITY
detroit, mi

DAY OF THE WEEK
sunday

LIQUID CONSUMED
pbr - 1 12oz bottle

TIME OF DAY
11:33pm est/04:33 gmt

TIME SPENT AT URINAL
31 mississippi

HANDWASHING SUPPLIES
clear liquid soap and a high
speed extreme hand dryer

COMPANY KEPT
sunday night beer at the bar
with an eclectic crowd and
curious conversation

WEATHER
chilly, cloudy 42°f/5°c evening

DISTANCE
240mi/386km from the toronto
skypod tower (a 3h 46m drive)

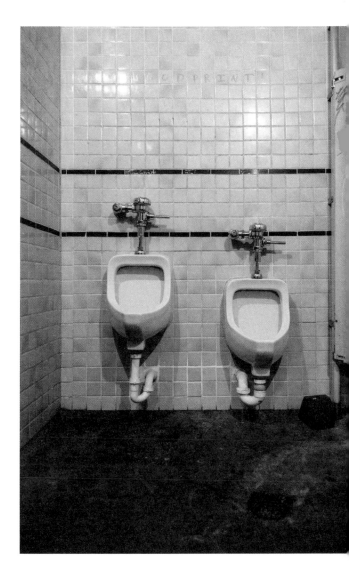

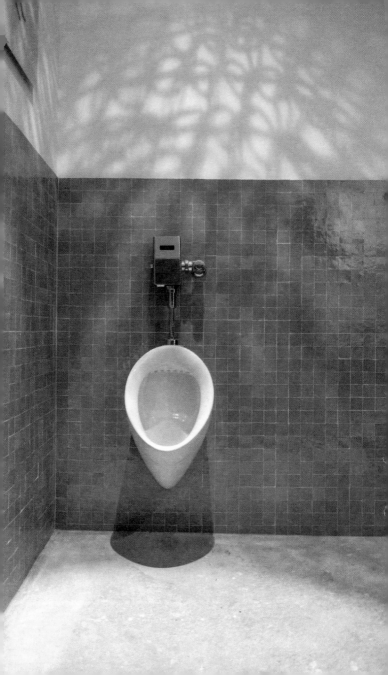

FOREIGN FORM

39°45'35.7"N / 104°59'02.1"W

STREET ADDRESS
2719 larimer street

CITY
denver, co

DAY OF THE WEEK
saturday

LIQUID CONSUMED
ratio domestica – 4 pints

TIME OF DAY
9:58pm mst/04:58 gmt

TIME SPENT AT URINAL
23 mississippi

HANDWASHING SUPPLIES
soothing aloe vera white
liquid soap and paper towels

COMPANY KEPT
checking out the work of hunter
s. thompson, ralph steadman,
and thomas w. benton, creators
of the gonzo movement

WEATHER
brisk 43°f/6°c december night

DISTANCE
221mi/356km from
aspen, co (a 3d 6h bike ride)

IGGY'S KELTIC LOUNGE

40°43'13.0"N / 73°59'17.3"W

STREET ADDRESS
132 ludlow street

CITY
new york, ny

DAY OF THE WEEK
saturday

LIQUID CONSUMED
pbr – 2 16oz cans (tall boys)

TIME OF DAY
8:18pm est/01:18 gmt

TIME SPENT AT URINAL
25 mississippi

HANDWASHING SUPPLIES
liquid soap and paper towels

COMPANY KEPT
a good chat with elke and oliver
about the ever changing new
york city, and getting the low
down on a band called girl
skin playing out in brooklyn
later in the evening

WEATHER
cold 31°f/0°c night

DISTANCE
3.1mi/4.9km from st. patricks
cathedral (a 1h 4m walk)

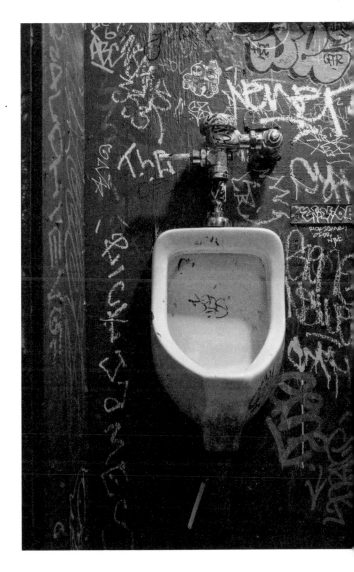

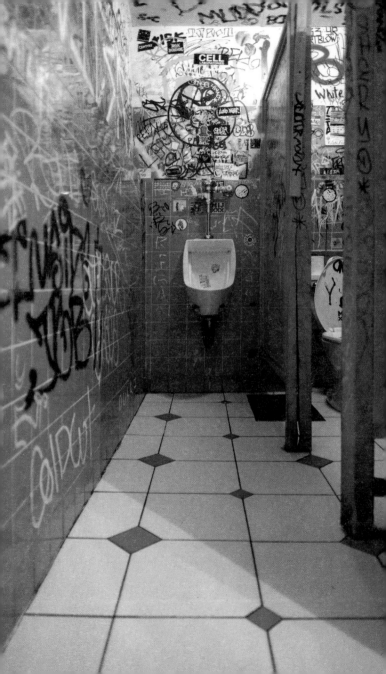

ALPHAVILLE
40°42'02.0"N / 73°55'32.9"W

STREET ADDRESS
140 wilson avenue

CITY
brooklyn, ny

DAY OF THE WEEK
saturday

LIQUID CONSUMED
budweiser – 3 12oz cans

TIME OF DAY
11:58pm est/04:58 gmt

TIME SPENT AT URINAL
24 mississippi

HANDWASHING SUPPLIES
foam soap and paper towels

COMPANY KEPT
a solid night catching up
with marthon and some
live music from girl skin

WEATHER
clear, cold 30°f/-1°c evening

DISTANCE
3,751mi/6,037km from münster,
germany (a 7h 36m flight)

LILLIE'S VICTORIAN ESTABLISHMENT

40°45'41.8"N / 73°59'09.4"W

STREET ADDRESS
249 west 49th street

CITY
new york, ny

DAY OF THE WEEK
sunday

LIQUID CONSUMED
brooklyn lager – 1 pint

TIME OF DAY
3:24pm est/20:24 gmt

TIME SPENT AT URINAL
26 mississippi

HANDWASHING SUPPLIES
foam soap and a high
speed xlerator hand dryer

COMPANY KEPT
a festive escape from
the madness that is
midtown manhattan

WEATHER
clear, cool 45°f/7°c afternoon

DISTANCE
3,460mi/5,568km from the
globe theater (a 6h 50m flight)

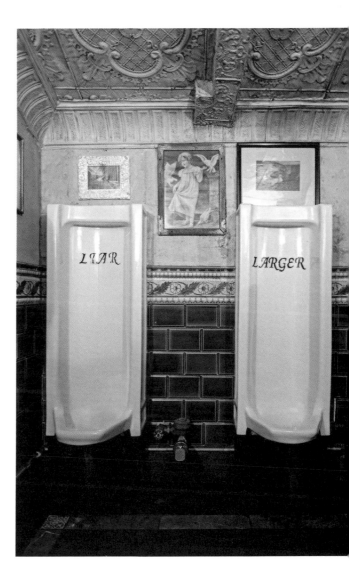

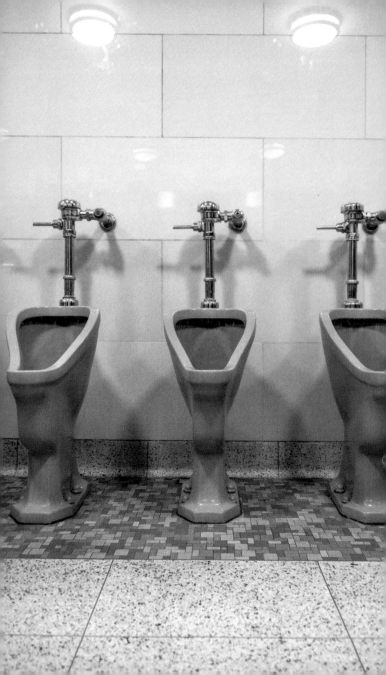

TATTERED COVER BOOKSTORE

39°44'23.8"N / 104°57'23.9"W

STREET ADDRESS
2526 east colfax avenue

CITY
denver, co

DAY OF THE WEEK
tuesday

LIQUID CONSUMED
cold brew – 16oz

TIME OF DAY
9:04am mdt/15:04 gmt

TIME SPENT AT URINAL
26 mississippi

HANDWASHING SUPPLIES
liquid soap and paper towels

COMPANY KEPT
a morning coffee and
magazine pick up

WEATHER
chilly 38°f/3°c morning

DISTANCE
1,691mi/2,721km from
the library of congress
(a 25h 47m drive)

STREET ADDRESS
1657 ocean avenue

CITY
santa monica, ca

DAY OF THE WEEK
saturday

LIQUID CONSUMED
trumer pils – 3 pints

TIME OF DAY
2:14pm pst/22:14 gmt

TIME SPENT AT URINAL
31 mississippi

HANDWASHING SUPPLIES
white liquid soap and
paper towels

COMPANY KEPT
an afternoon of beers and
catching up with mack

WEATHER
partly cloudy, comfortable
63°f/17°c day

DISTANCE
0.2mi/0.3km from the santa
monica pier (a 5m walk)

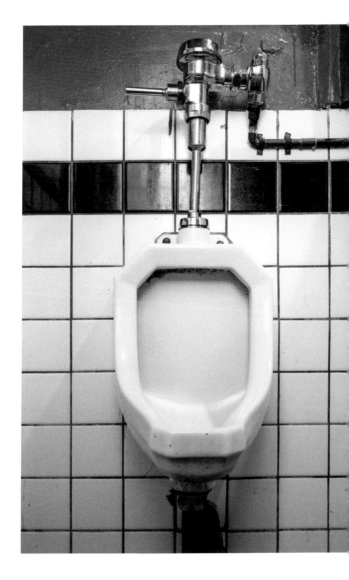

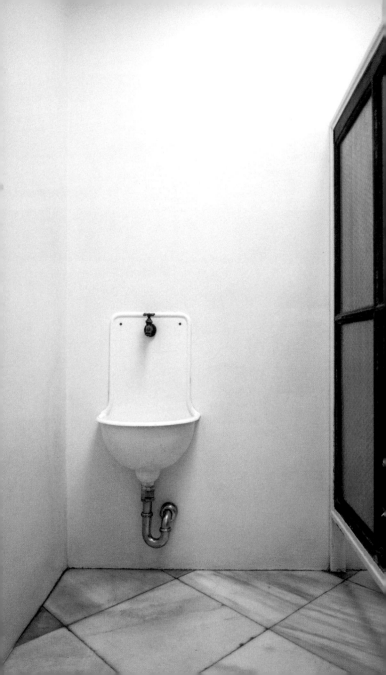